1001 CARTOON-STYLE ILLUSTRATIONS

J. I. Biegeleisen

and

Dave Ubinas

DOVER PUBLICATIONS, INC.
New York

Bibliographical Note

This Dover edition, first published in 1996, is an unabridged and slightly altered republication of the revised work first published by Arco Publishing, Inc., New York, in 1983 under the title *Clip-Art Book of Cartoon-Style Illustrations*. For the Dover edition, the second part of the original work, instructional advice for studio artists titled "Section II," has been omitted. A new Publisher's Note has been prepared specially for the Dover edition.

DOVER *Pictorial Archive* SERIES

Library of Congress Cataloging-in-Publication Data

Biegeleisen, J. I. (Jacob Israel), 1910–
 1001 cartoon-style illustrations / J. I. Biegeleisen and Dave Ubinas. — Dover ed.
 p. cm. — (Dover pictorial archive series)
 Rev. ed. of: Clip-art book of cartoon style illustrations / Dave Ubinas. New York : Arco Pub., 1983.
 Includes index.
 ISBN 0-486-29047-6 (pbk.)
 1. Cartooning—Technique. 2. Caricatures and cartoons—Themes, motives.
3. Artists' materials. 4. Clip art. I. Ubinas, Dave. II. Ubinas, Dave. Clip-art book of cartoon style illustrations. III. Title. IV. Series.
NC1320.B54 1996
741.6—dc20 95-39683
 CIP

Manufactured in the United States of America
Dover Publications, 31 East 2nd Street, Mineola, N.Y. 11501

Publisher's Note

Artists, designers, craftspeople and anyone wanting to add a light-hearted touch to memos, flyers or ads will find this volume of over 1000 cartoon illustrations an invaluable resource. The illustrations have been arranged in broad categories and also in a Subject Selector Index which gives the locations of specific cartoons for easy reference.

The black-and-white illustrations can be traced or copied, colored for a little extra flair, or can simply serve as a source of ideas and inspiration.

Contents

Subject Selector Index

(listed by illustration number)

Brashness 507
Brass band 399, 746
Brazil 686
Breakup 469
Breeze 836
Bridal shower 105
Bride 102
Bride and groom 103, 106
Bridge 619
Bright idea 865
Broadcaster 459
Broke 816
Bronco buster 636
Brotherhood 906, 908
Brute 909
Buddha 654
Bugle 748
Bugler 124, 128, 156, 753
Bulldog 955
Bull fight 721
Burden 808, 812
Burgler 980
Business 460, 468, 473, 497, 578, 987
Butterfly 544, 968

Cactus 627, 630
Caduceus 487
Cake 347
Camel 650
Cameo 67
Camera 461, 748
Camping 220, 264
Camp trailer 260
Candelabra 50, 713
Candle 6, 8
Cannon 167
Canoeing 237
Cap and gown 425, 433
Capitol dome 712
Captain 601
Captivity 841, 842
Car 554, 575, 606
Caribbean 678, 716
Carolers 1, 18, 22
Carpenter 482
Carpentry 498
Cash 411, 416
Cash register 1010
Castle 586
Cat 944, 945
Cave man 909, 911, 914
Ceiling fan 557
Ceremonial mask 709
Chain 904
Chained 842

Chair 553
Chalet 671
Challenge 398
Champagne 32, 377, 380
Change purse 897
Chanukah 50
"The Chase" 580
Chauffeur 489
Cheer leader 434
Chef 287–290, 293–296, 299, 301, 302, 308, 311
Chemistry 476, 777
Cherries 362
Cherub 59, 62
Chickens 933
Children's party 139
Christmas 1–30
Church 27, 426
Cider jug 368
Cinema 745
Circus 386–394, 397, 400, 402–408, 414, 418, 422–424
Clairvoyance 412, 882
Clams 329
Cleaning tools 493
Cleopatra 702
Clever 809, 860
Clock 439
Clown 147, 155, 386, 392, 400, 404, 408
Clown's sceptre 756, 758
Coal miner 516
Coal stove 568
Cocktails 118, 140, 143, 145, 379, 383
Coffee cup 369, 370, 376
Cogged wheels 972
Coins 794
Cold 611, 832
College 435
College professor 443
Color 863
Colosseum 681
Columbus day 80, 83, 85
Comedy and tragedy masks 736, 757
Coming attractions 151
Coming events 168
Coming soon 147, 149
Command 507
Committee 900
Communication 845
Compass 600
Complacency 787
Concert pianist 729, 769

Condiments 343, 344
Conductor 749, 760, 763, 765
Confidential 811, 874
Conflict 643
Conservation 890
Cooperation 422, 904, 906
Copernicus 773
Corn stalk 546
Cossack 701
Cottage 539
Country music 751
Country school 440
Courier 874
Court 899
Courthouse 435
Cowboy 636, 641, 959
Crab 348
Cradle 109
Crazy 988
Creepy 807
Crocodile 847
Crossed swords 643
Crowing rooster 153, 177, 188, 941
Crown 870, 970
Crystal ball 412, 887
Culture 732
Cupid 59, 62
Curiosity 149
Cut prices 1011

Dachshund 956
Daffy 988, 989
Danger 645, 806, 838
Dancing 266–286, 725, 727, 728
Daredevil pilot 582
Death 645
Debts 812
Democracy 802, 803
Delivery van 1000
Delusion 748
Desert 630
Desire 910
Detective 875, 878, 880
Devil 913, 915, 916
Diamond 982
Dice 395, 419
Dictation 473
Dining 291, 306
Dinosaur 918, 919
Diploma 430, 457, 458
Direction 600, 800, 1004, 1005
Director's chair 741

807, 873, 875–881

Sergeant 507
Saving 792, 890–898
Scales of Justice 902
Scavenger 922
Scheming 809, 860
School bell 428
School bench 438
Schoolbooks 442, 453
Schoolboy 436, 446, 455
School clock 439
School guard 178
School material 444
Schoolhouse 426, 440
Schoolmarm 431
Science 483, 777
Scotchman 898
Scotland 685
The Sea 655, 846–853
Seafood 348–355
Sea gull 935
Sea horse 846
Seal 406
Sea monster 917
Secret 811
Secretary 460, 471, 473, 512
Security 874
Self-delusion 864
Self-esteem 787
Self-satisfaction 787
Serpent 910
Shackled 842
Shadow 873
Shaggy 958
Shamrock 76
Shark 921
Shell game 421
Shelter 990
Sheriff's badge 999
Sherlock Holmes 875, 878
Ship ahoy! 614, 648
Shipping 656
Ship's captain 601, 616
Shofar 46
Shopper 310
Shopping 24
Showman 409
Show opener 408
Sighting 614, 648
Signal 806, 845
Silo 521
Singing quartet 576
Sinister 807
Sinking 815
Sitting on top of the world 786
Skating 238, 240, 243

Skeleton 89
Skiing 215
Skull and crossbones 645
Skunk 839
Skywriting 388
Slavery 842, 904
Sled riding 26
Sleuth 875, 878, 880
Slot machine 413, 420
Slowness 822, 823
Slyness 809, 860
Smelly 839
Smoke signals 845
Snail 822
Snake 910
Snake charmer 663
Sneak 915
Snowman 4
Social and commercial announcements 100–191
Sombrero 720
S.O.S. 819
South sea island 652, 689, 696
Space 609
Space ship 610, 621
Space travel 682, 688
Spain 700, 721
Speaker 491
Special event 190
Speed 196, 478, 505, 821, 825–829, 867
Spider 807
Spiderweb 805
Sports 192–228, 238, 240, 242–244
Spotlight 739, 747
Spring 871, 923–931
Spy 873
Spy glass 876
Squirrel 890, 895, 936
Stack of coins 794
Stage 738
Star of David 49
Statue of Liberty 803
Steak platter 323
Steam locomotive 561, 581
Steamship 603, 618
Stenographer 471, 512
Stethoscope 499
Sticky 937
Stop sign 178, 978
Stork 110, 113, 116
Storm 837
Stove 552, 568
Strawberry festival 162

Strength 394, 398, 808
Striking it rich 790, 791, 795
Strong man 394
Strutting 863
Stubbornness 872
Success 770, 772, 783, 786
Suggestion box 901
Sunbathing 239, 241, 253, 255, 257
Sundial 961
Sunshine 833
Superman 824
Surfing 256
Surprise 583
Surveillance 873, 875, 878–880
Swami 401, 405
Swan 934, 947
Sweating 834
Swimming 244, 254
Swimming pool 241
Switchboard operator 509
Switzerland 671

Take off 625
Target 222
Target practice 230
Tea set 373, 375, 378
Teacher 431, 441
Teddy bear 588, 592
Telephone 101, 133, 136, 556, 987
Telescope 502
Television announcer 459
Temptation 910, 915
Tennis 201, 203, 204
Tent 220, 264
Test of strength 398
Thanksgiving 79, 81, 82, 84, 96–98
Theater 151
Theater symbol 736, 757
Theatrical presentation 738
Thermometer 830, 831
Thrift 890–898, 936
Thunder 837
Tiffany lamp 567
Tiger 415
Time 854, 856
Toad 851
Tobacco 560
Togetherness 906
Torah 52
Torch 903
Tortoise 823

1

2

3

4

5

6

7

8

9

10

11

12

13

14

15

16

17

18

19

20

21

22

23

24

25

26

27

28

29

30

31

32

33

34

35

36

37

38

39

40

41

42

43

44

45

14 NATIONAL AND RELIGIOUS HOLIDAYS

46

47

48

49

50

51

52

53

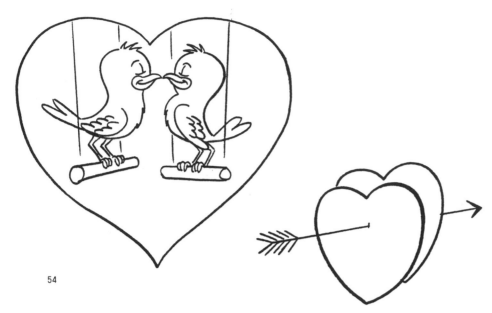

54

55

56

VALENTINE

57

58

59

Love

60

61

62

63

64

67

65

66

70

68

69

71

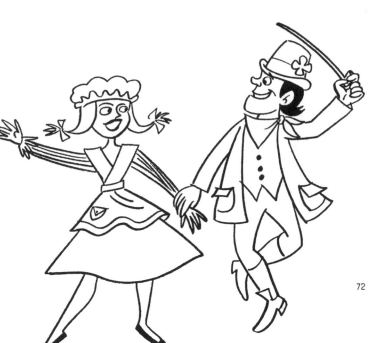

72

73

74

75

76

77

78

79

80

81

82

83

84

85

86

87

88

89

90

91

92

93

94

95

96

97

98

99

100

101

102

103

104

105

106

107

108

109

110

111

112

113

114

115

116

117

118

119

120

121

129

130

131

132

133

134

135

136

137

138

139

140

141

142

143

144

145

146

147

148

149

150

151

152

153

154

155

156

157

158

159

160

161

162

163

164

165

166

167

168

169

170

171

172

173

174

175

176

177

178

179

180

181

182

COAST TO COAST

183

ANNIVERSARY SALE

184

sale

185

186

187

188

189

190

191

192

193

194

195

197

196

198

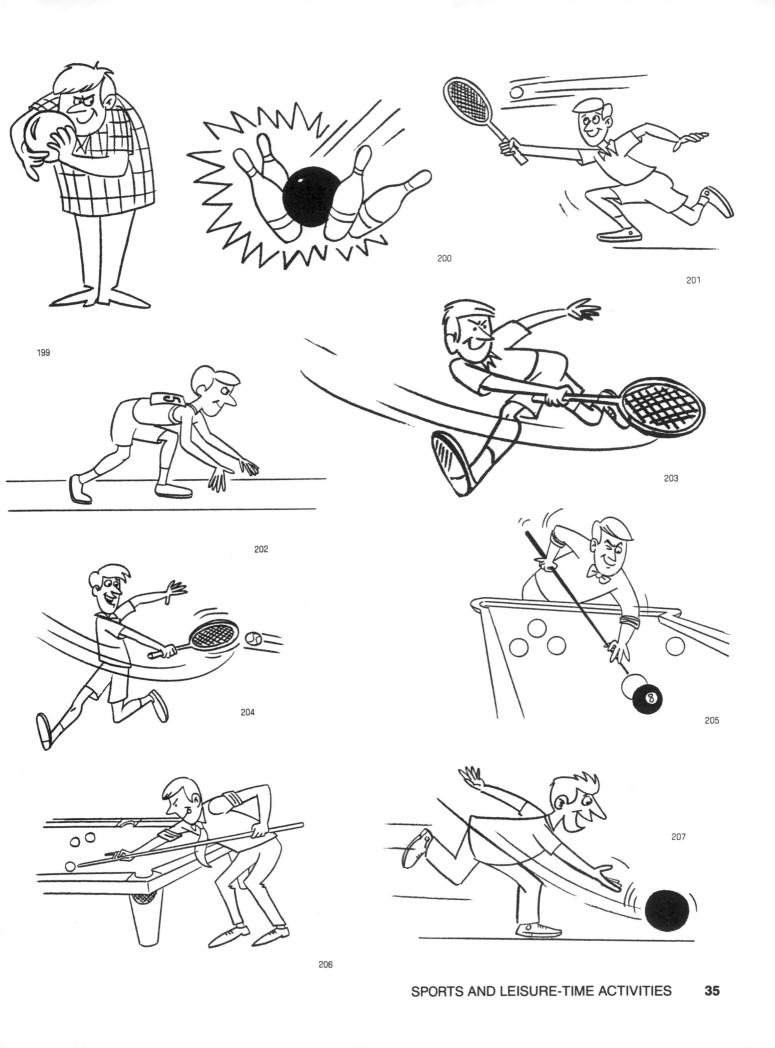

199

200

201

202

203

204

205

206

207

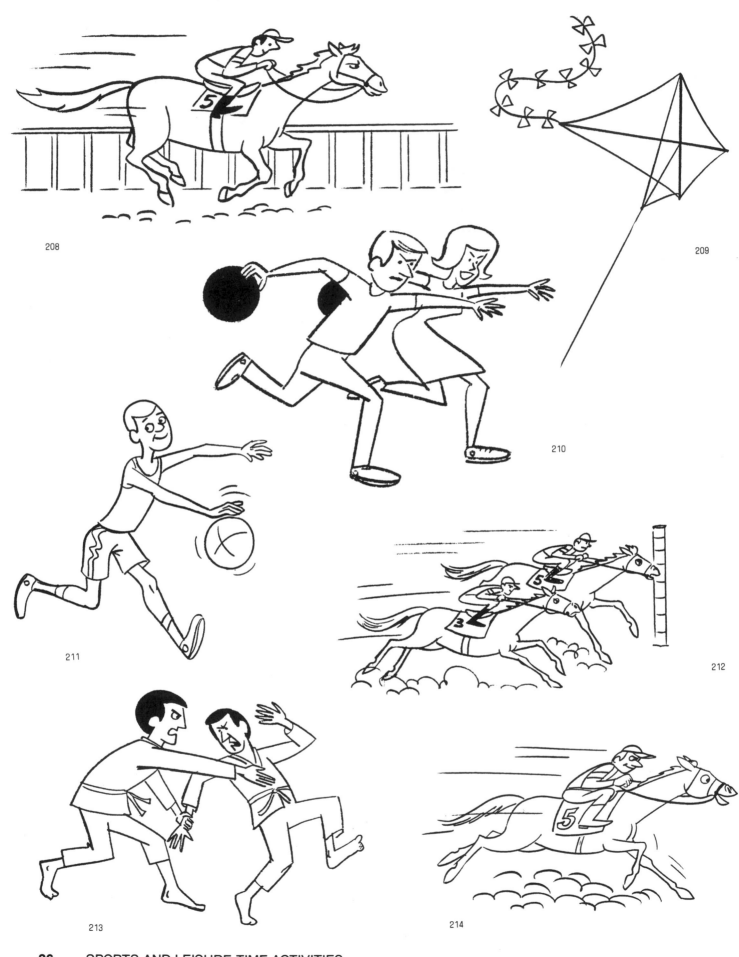

208

209

210

211

212

213

214

215

216

217

218

219

220

SPORTS AND LEISURE-TIME ACTIVITIES **37**

221

222

223

224

225

226

227

228

SPORTS AND LEISURE-TIME ACTIVITIES

229

230

231

232

233

234

235

236

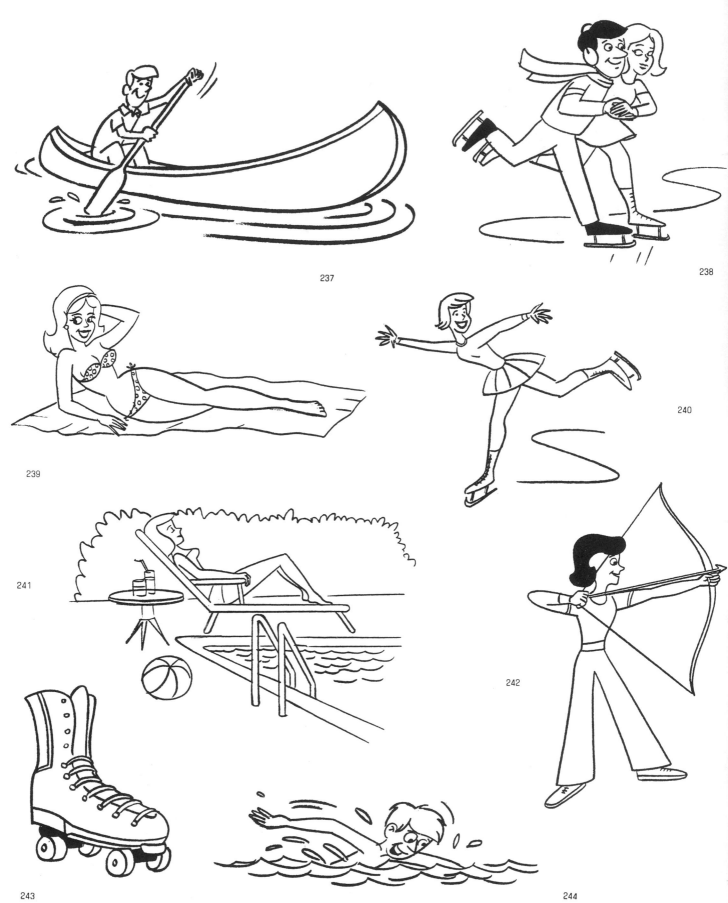

237

238

239

240

241

242

243

244

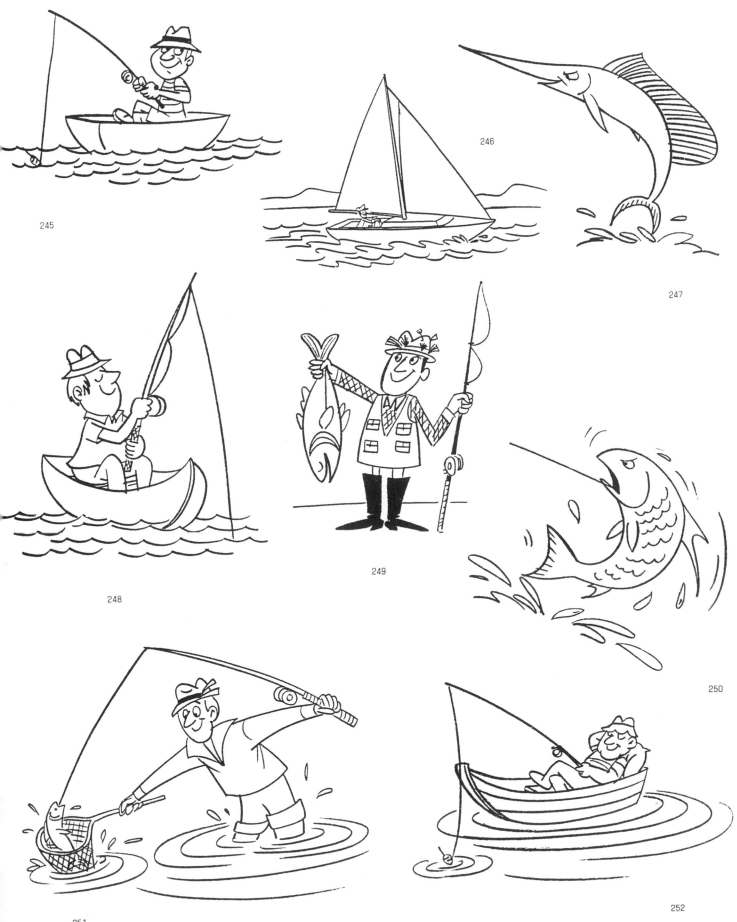

245

246

247

248

249

250

251

252

253

254

255

256

257

258

259

260

261

262

263

264

265

SPORTS AND LEISURE-TIME ACTIVITIES **43**

266

267

268

269

270

271

272

273

274

275

276

277

278

279

280

281

282

283

284

285

286

287

288

289

290

291

292

293

294

295

296

297

298

299

300

301

302

303

304

305

306

307

308

309

310

312

311

314

313

315

316

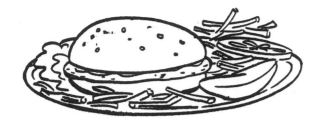

317

318

319

321

320

322

323

FOODS AND THE CULINARY ARTS **51**

324

325

326

327

328

329

330

331

332

333

334

335

336

337

338

339

FOODS AND THE CULINARY ARTS **53**

340

341

342

343

344

345

346

347

348

349

350

351

352

353

354

355

356

357

358

359

360

361

364

362

363

365

366

367

368

369

370

371

372

373

374

375

376

377

378

379

380

381

382

383

384

385

386

387

BAZAAR

388

389

390

391

392

393

394

395

396

397

398

399

400

401

402

403

404

405

406

407

408

409

410

411

412

413

414

415

416

417

418

419

420

421

422

423

424

425

429

426

427

428

DIPLOMA

430

4+7=

4×11=

431

432

433

434

435

437

436

439

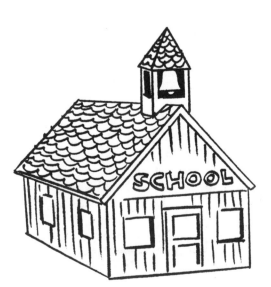

438

441

440

442

443

444

445

446

447

INK

HOW TO UNDERSTAND PARENTS

HOW TO UNDERSTAND PARENTS

448

449

450

451

452

453

454

455

456

457

458

459

460

461

462

463

464

465

466

467

468

469

470

471

472

473

474

475

476

477

478

479

480

481

482

483

484

485

486

487

488

490

489

491

492

493

494

495

496

497

498

499

500

501

502

503

506

504

505

507

508

509

510

511

512

5 13

514

515

516

517

518

519

520

521

522

523

524

525

526

527

528

529

530

531

532

533

534

535

536

537

538

539

540

541

542

543

544

545

546

547

548

549

550

551

552

554

555

556

557

558

559

560

561

562

563

564

565

566

567

568

569

570

571

572

573

574

575

576

577

578

579

580

581

582

583

584

585

586

587

588

589

590

591

592

593

594

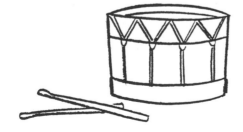

595

596

597

599

600

598

601

602

603

604

605

606

607

608

609

610

612

611

613

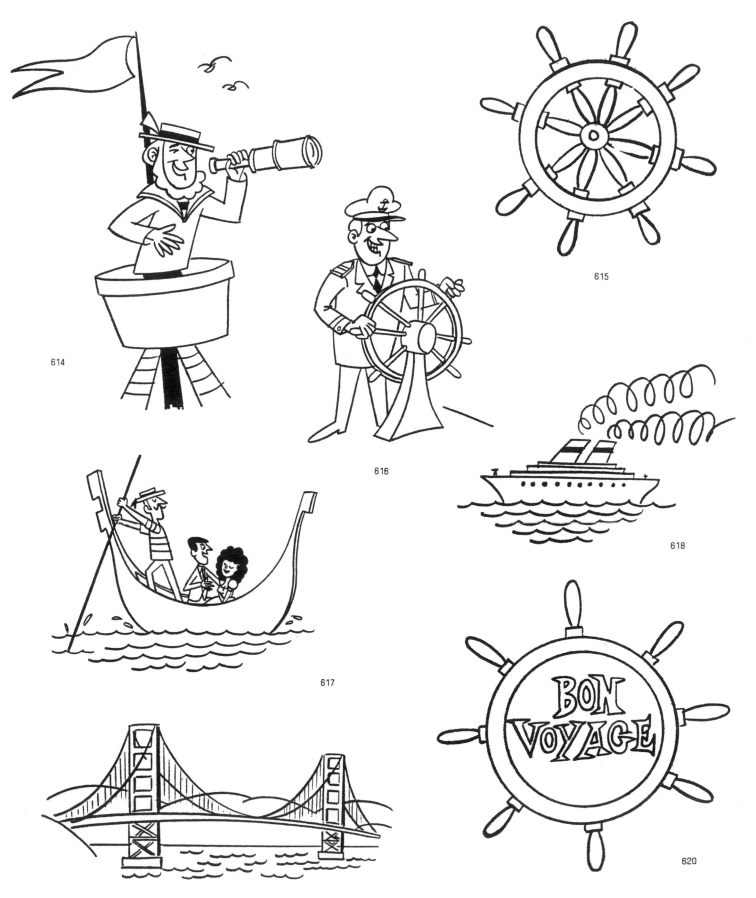

614

615

616

617

618

619

620

621

622

623

624

625

626

627

628

629

630

631

632

633

634

635

636

637

638

641

640

639

642

643

644

645

646

647

648

649

650

651

652

653

654

655

656

657

658

659

660

661

662

663

664

665

666

667

668

669

670

671

672

673

674

675

676

677

678

679

680

681

TRAVEL AND GEOGRAPHIC LANDMARKS **95**

682

683

684

685

686

687

690

688

689

691

692

693

694

695

696

697

698

699

700

701

702

703

704

705

706

707

708

709

710

711

712

713

714

715

716

717

718

719

720

721

722

723

724

725

726

727

728

729

730

731

732

733

734

735

736

737

738

739

740

741

742

743

744

745

746

747

748

749

750

751

752

753

754

755

756

757

758

759

760

761

762

763

764

765

766

767

768

769

770

771

772

773

774

775

776

777

778

779

780

781

782

783

784

785

786

787

796

797

798

800

799

801

802

803

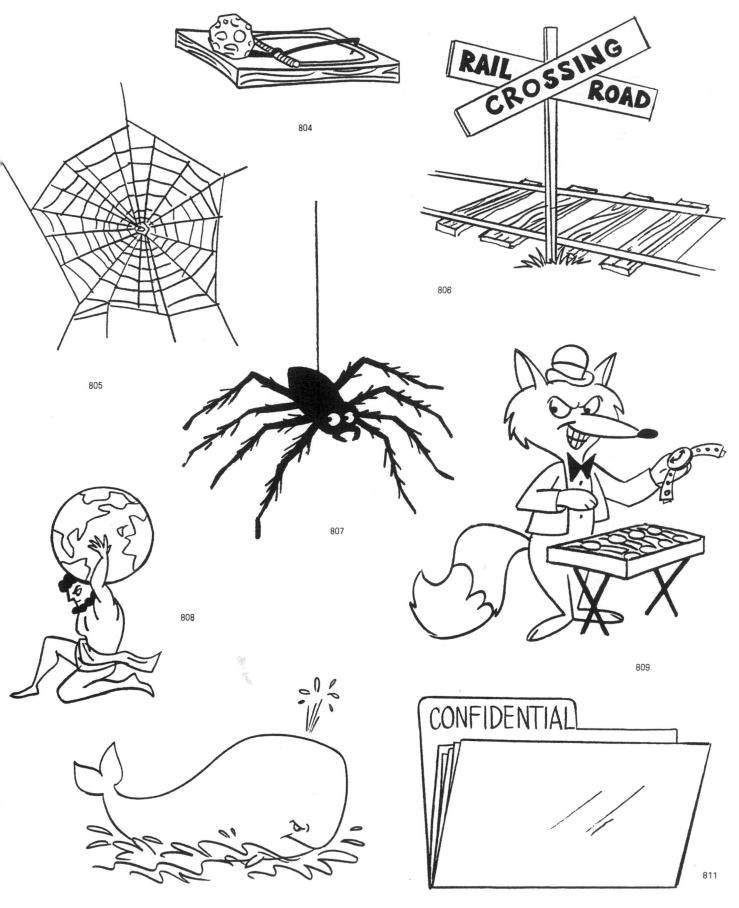

804

805

806

807

808

809

810

811

812

813

814

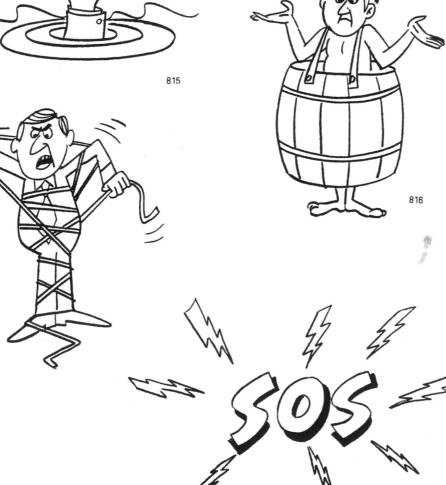

815

816

817

818

820

819

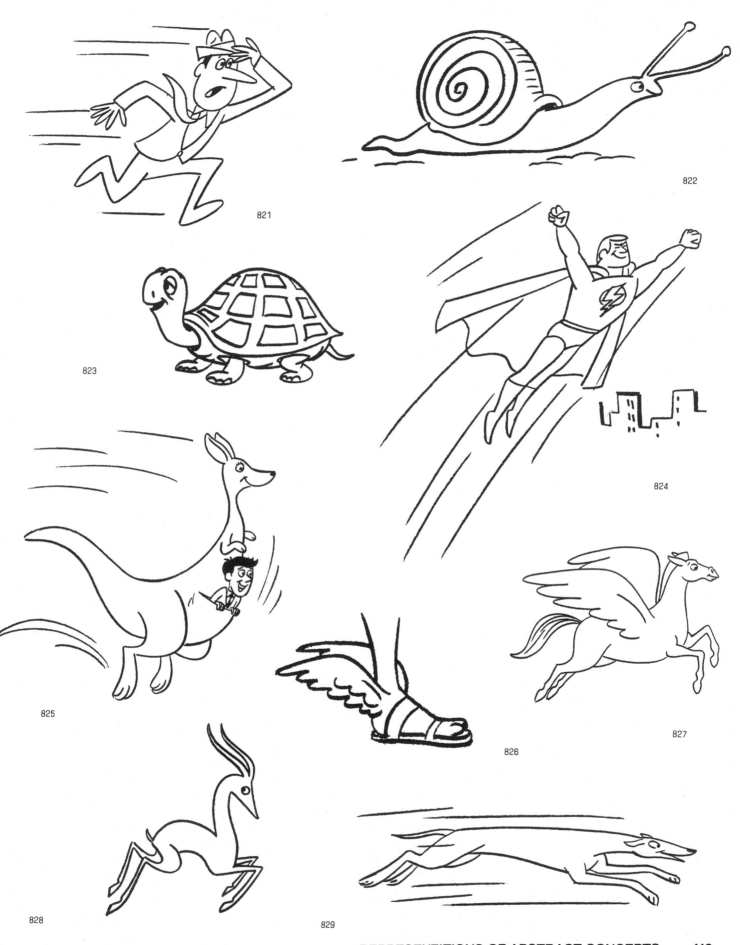

821

822

823

824

825

826

827

828

829

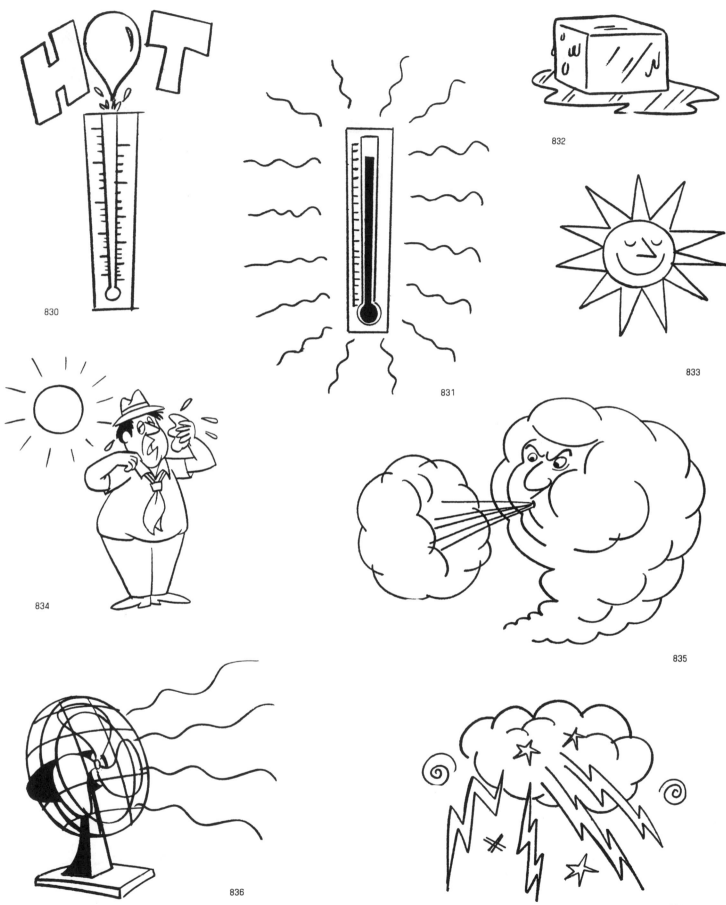

830

831

832

833

834

835

836

837

REPRESENTATIONS OF ABSTRACT CONCEPTS

838

839

841

840

842

843

844

845

847

848

846

849

850

851

852

853

854

855

856

POWER

857

858

859

860

861

862

863

864

865

866

867

868

869

870

872

871

873

874

875

876

877

878

879

880

881

882

883

884

885

886

887

888

889

890

891

892

893

894

895

896

897

898

899

900

SUGGESTION
BOX

901

902

903

904

905

906

HOLY BIBLE

907

908

909

910

911

912

913

914

915

916

918

917

920

919

921

922

923

924

925

926

927

928

929

930

931

932

933

934

935

936

937

938

939

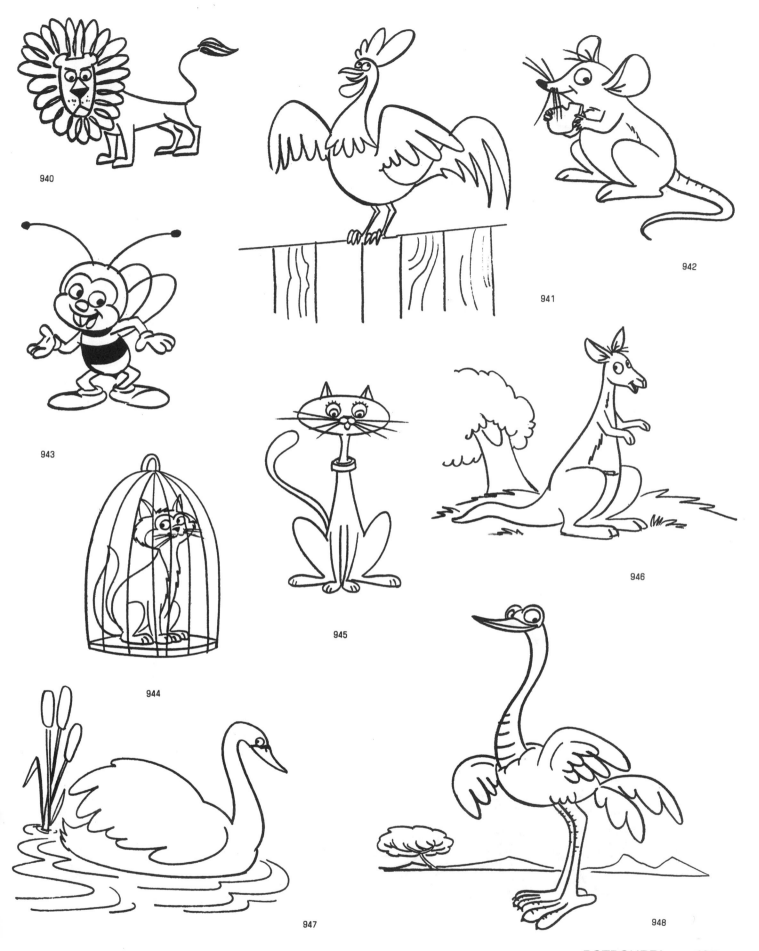

940

941

942

943

944

945

946

947

948

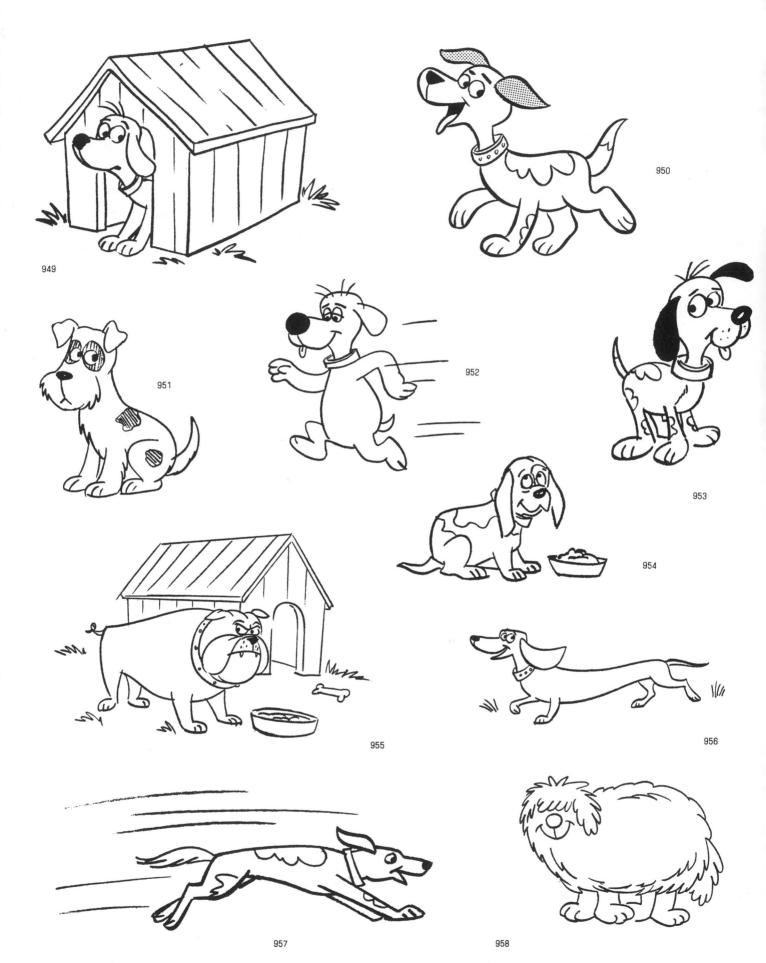

949

950

951

952

953

954

955

956

957

958

959

960

961

962

963

964

965

966

967

968

969

970

971

972

973

974

975

976

977

978

979

980

981

982

DO NOT DISTURB

984

WHAT'S NEW?

983

985

986

987

988

989

990

991

992

993

994

995

996

997

999

SHERIFF

998

1000

JUDGES

AUCTION

ART AUCTION

1001

1002

1003

1004

1005

1007

1006

1008

1009

1010

1011